A Guide to
Contemporary Portraits

Sarah Howgate and Sandy Nairne

National Portrait Gallery

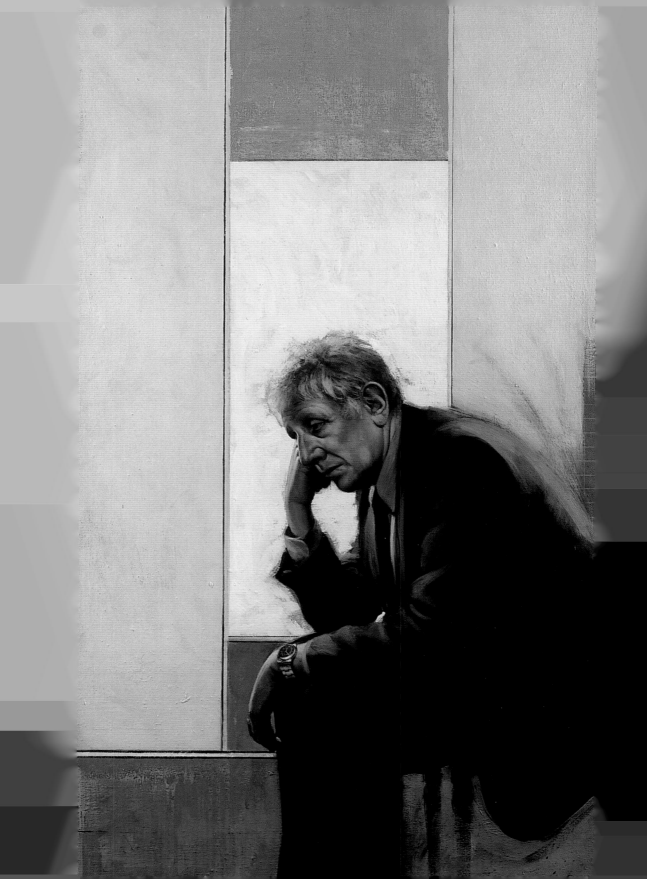

Contents

Foreword

The National Portrait Gallery in London houses the foremost portrait collection in the world. Although it continues to acquire significant historical painted portraits, the development of the Contemporary Collection is of great importance, with works added both by purchase and by commission. A large number of photographs and a smaller quantity of paintings, sculptures and digital works, are acquired every year, and all are chosen because of the sitter.

Two key decisions have enabled the Gallery to engage with contemporary portraiture. In 1969 the Gallery changed its policy to allow portraits of living persons to enter the Collection, and in 1979 the Gallery began commissioning portraits on a regular basis. Funds are set aside to ensure that a number of eminent individuals – whether an outstandingly innovative figure in business such as Sir Richard Branson (opposite above) or a brilliant academic, writer and critic in the case of Germaine Greer (opposite below) – of whom good portraits may not otherwise be available, can be created for the Collection. With such commissioned works, the most appropriate artist is chosen to depict a particular person.

Whatever the style or medium, and whoever the subject, a good contemporary portrait can intrigue and delight. The viewer may want to check the label to note the artist or photographer, or to know more about the sitter's life and achievements, but the fundamental interaction is immediate and intimate. The contemporary portrait thus offers an engagement with the world around us, and commissioned portraits are likely to be 'portraits of honour', whether painted or photographed at the request of an institution, for a family or even for an individual. They complement but contrast with those 'portraits of affection' that we might keep in the photo album, in our wallets, (or on social-network sites), capturing friends and loved ones as they pose on holiday, a day out or a celebration of some kind.

The idea of capturing likenesses, of conveying a particular individual – in whatever medium – is remarkably ancient, but has been subject to renewal, regeneration and, over the past

Portrait of A.S. Byatt: Red, Yellow, Green and Blue: 24 September 1997
Patrick Heron (1920–99)
Oil on canvas, 1997
968 × 1216mm
NPG 6414

The portrait of novelist A.S. Byatt (b.1936) was the third by Patrick Heron to enter the Gallery's Collection and was painted some fifty years after his semi-cubist image of T.S. Eliot. Heron's distinction as an abstract artist was relevant to the sitter's wishes: 'What I wanted was the presence of the idea of me.' The portrait was the result of three visits to Heron's studio in St Ives, Cornwall.

150 years, massive expansion. Whereas in the classical and medieval worlds images of people would appear on a coin, in the sculpted likeness of a powerful ruler, or occasionally as a funeral image, today images of others are ubiquitous. This development may connect everyone to portraiture in some form, but it means that portraits are part of our environment in a much wider sense than other forms of contemporary art.

Contemporary portraits, as we encounter them in galleries and museums, are important as works of art because they reflect the development of human depiction with skill, clarity and depth. Often they mix the subject with the times, describing a cultural moment and giving viewers the chance to assess the particular sitter. Sometimes these portraits manifest expressive and psychological qualities just as much as a literal likeness of their subject. However formal, the contemporary portrait conveys personality as well as stature, as in Stephen Conroy's magisterial portrait of physician, theatre and opera director Sir Jonathan Miller (p.2). Stephen Conroy is noted for his preoccupation with the human figure in isolation and for his traditional depiction of figures in formal poses. In contrast, the swirling colours of Patrick Heron's portrait of A.S. Byatt (opposite), work on a metaphorical level to convey the creativity and verve of this writer of complex fiction.

Yet portraits matter precisely because they are lifted out of the everyday, away from the mundane image-making of the media. And the best portraits are treasured because they lead us to understand those individuals who are important to us, as well as those who are significant in the wider world, because they can encourage recognition and affection, admiration and inspiration.

This guide looks at over fifty key contemporary works from the National Portrait Gallery's Collection, offering fresh insights into the intimate relationship between artist and sitter, and featuring interviews with artists to reveal fully the importance and influence of contemporary portraiture.

Sandy Nairne
Director, National Portrait Gallery

Sir Richard Branson
David Mach (b.1956)
Mixed media (postcard and photo-collage), 1999
1824 × 1826mm
NPG 6494

Scottish artist David Mach has acquired a reputation for his witty and inventive use of unusual materials. His portrait of Sir Richard Branson (b.1950) captures a likeness of the business entrepreneur in collage form, his face includes numerous postcards of the Gallery's self-portrait by Dame Laura Knight.

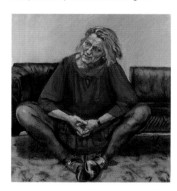

Germaine Greer
Paula Rego (b.1935)
Pastel on paper laid on aluminium, 1995
1200 × 1111mm
NPG 6351

Paula Rego's portrait of Germaine Greer (b.1939), academic and author of the key feminist text *The Female Eunuch* (1970), was painted during thirty hours of sittings in the artist's London studio, during which Rego and Greer listened to Wagner's Ring cycle in its entirety.

Recent developments in contemporary portraiture

In the twenty-first century, contemporary portraiture has been refreshed with shifts of styles in painting, photography and sculpture. These shifts have allowed the subject to be presented outside the traditional conventions of formal portraiture. Tony Bevan's painted portrait of the pianist Alfred Brendel (p.15) adopts a radically graphic and expressionist style. Maud Sulter's photographic depiction of the writer Bonnie Greer shows the sitter dressed in neoclassical style but shot against a contemporary background (p.12). Challenging and provoking, Marc Quinn's cast of his head, made from his own blood and then frozen (p.41), pushes boundaries still further, raising questions about the nature of portraiture itself.

The format of the portrait has also been transformed by ambitious approaches in presentation. In some instances, this was a matter of discovering innovative means to convey a particular person in a telling, and sometimes surprising, way. In others, it was due to the development of new media, which have added to the achievements of photography over the past 150 years. Sam Taylor-Wood's digital film portrait of David Beckham asleep (opposite) consciously references the work of Andy Warhol, who created his iconic Screen Test portraits in the 1960s and also made a cult film with his subjects asleep. But the intimacy of Taylor-Wood's work is almost shocking, allowing us to get unnervingly close to a figure of worldwide fame. Equally disarming is Michael Craig-Martin's computer portrait of the international architect Zaha Hadid (p.8). Her neatly inscribed outline is filled with an ever-changing mix of hues and colours, mirroring the flux and dynamism of her award-winning buildings.

The National Portrait Gallery's commitment to contemporary portraiture is expressed not only in the annual commissions of individual portraits and in photographic group projects, but also through the two official annual international competitions, the Portrait Award for painters and the Photographic Portrait Prize.

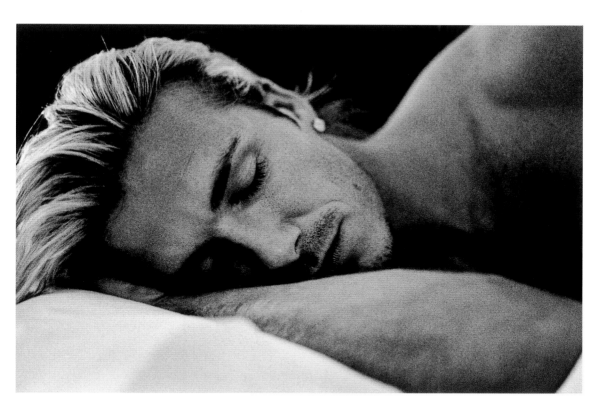

David
Sam Taylor-Wood (b.1967)
Digital film displayed on plasma screen, 2004
Commission made possible by J.P. Morgan through
the Fund for New Commissions, 2004
NPG 6661

Appointed England captain in 2000, footballer David
Beckham (b.1975) led his team to a memorable place
in the World Cup in 2002, but then moved to Spain
to play for Real Madrid before joining American
professional soccer club, the Los Angeles Galaxy.
This portrait captures Beckham asleep at siesta time,
exhausted after a long morning's training. In contrast
to her earlier staged conversation pieces, Sam Taylor-
Wood here returns to a naturalistic scene shot in
real time. Drawing on diverse influences from
Michelangelo to Andy Warhol, she has produced an
intimate and collaborative portrait, for which only the
artist and subject were present. Simply lit, the result
is a vulnerable image of a national icon captured
off-guard, a far cry from his familiar public persona.

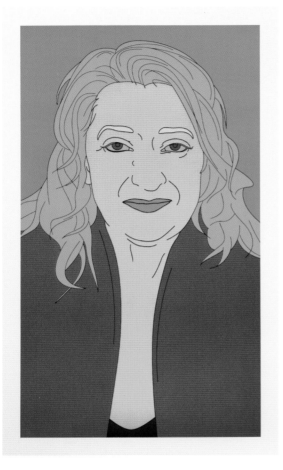
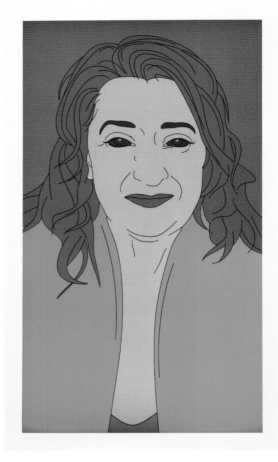

Zaha Hadid
Michael Craig-Martin (b.1941)
Wall-mounted LCD monitor/computer
with integrated software, 2008
Commission made possible by J.P. Morgan through
the Fund for New Commissions, 2008
NPG 6840

Iraqi-born Zaha Hadid (b.1950) was the first woman to
win the Pritzker Prize for Architecture. Her work, which
includes the London Olympic Aquatics Centre (2012),
is characterised by multiple perspective points and
fragmented geometry, designed to evoke the chaos of
modern life. This portrait marks a new departure for
British conceptual artist Michael Craig-Martin. Although
his linear portrait of Hadid, based on photographs
taken by the artist, is fixed, its saturated colour palette
changes over time in infinite combinations. Just as
Hadid uses computer-aided design to show the fluid
nature of her spaces, her own likeness is appropriately
realised as a computer portrait in a state of flux.

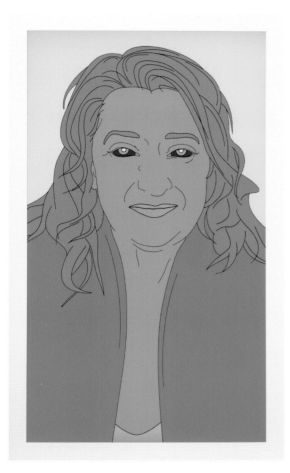 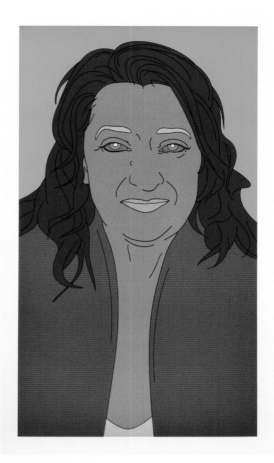

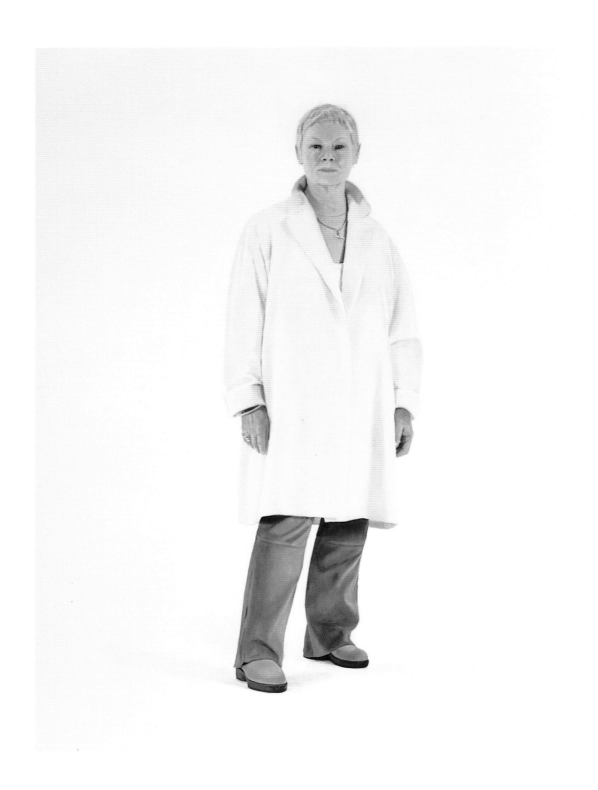

Dame Judi Dench
Alessandro Raho (b.1971)
Oil on canvas, 2004
2521 × 1759mm
Commission made possible by J.P. Morgan through
the Fund for New Commissions, 2004
NPG 6671

Leading actress of stage and screen, Dame Judi Dench
(b.1934) is known for her acting roles with the Royal
Shakespeare Company and the National Theatre, and
for her Oscar-nominated performances in films such
as *Iris* (2001) and *Mrs Henderson Presents* (2005). In this
striking full-length painting, with its strong awareness
of the tradition of English theatrical portraits, artist
Alessandro Raho depicts his subject unadorned,
without prop or costume, against a neutral background
– a reversal of his usual practice of 'dressing up' his
subjects. Although photography is an integral part of
Raho's practice, the portrait retains painterly qualities
in the delicate brush strokes and soft tonal effect.

Peter Saville
Wolfgang Tillmans (b.1968)
C-type print, 2002 (1 of 3)
610 × 508mm
Purchased through the Deloitte
Acquisition Fund, 2003
NPG P1010

Peter Saville (b.1955) has been a pivotal figure in
design and style culture since his collaboration with Joy
Division as co-founder of Factory Records in the late
1970s, and is one of few graphic designers to become
a household name. As a chronicler of contemporary
life in his photography, Wolfgang Tillmans makes the
ordinary and everyday appear extraordinary, as in this
portrait of the luxuriously robed and casually posed
Saville. Tillmans works collaboratively with his sitters,
allowing himself to become a participant in the scene.
This portrait was selected to illustrate *Designed by Peter
Saville*, published to coincide with his retrospective at
the Design Museum, London (2003).

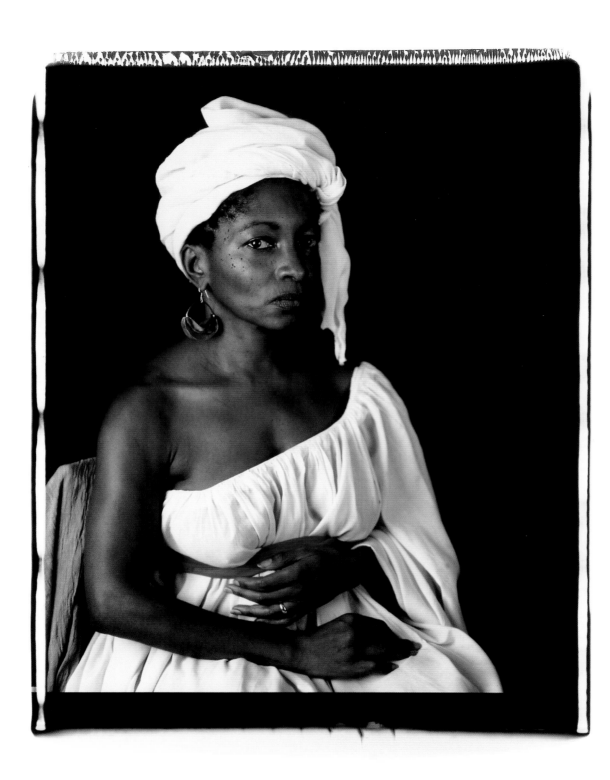

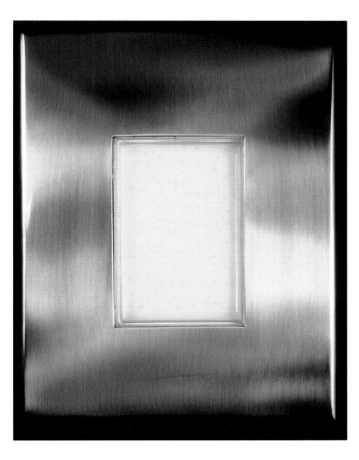

Sir John Edward Sulston
Marc Quinn (b.1964)
Sample of sitter's DNA in agar jelly mounted
in stainless steel, 2001
127 × 85mm
Funded by the Wellcome Trust, 2001
NPG 6591

Nobel Prize-winning scientist Sir John Sulston (b.1942)
is a central figure in the development of DNA analysis
and interpretation. From 1992 to 2000 he was
Director of the Sanger Centre, Cambridge, where he
directed the British contribution to the international
Human Genome Project. This portrait of Sulston
by Marc Quinn develops links between science and
the arts, raising questions regarding the conceptual
representation of the individual. Although entirely
abstract, it is an acutely accurate representation of
the subject's essential identity since it is composed
of his own DNA. Much of Quinn's work explores
identity through a focus on the body's form, both
in terms of materials used and representation.

Bonnie Greer
Maud Sulter (1960–2008)
Colour Polaroid print, 2002
804 × 560mm
NPG P965

American-born broadcaster, playwright and critic,
Bonnie Greer (b.1948) came to London in 1986,
rapidly establishing herself as a prominent figure
in British culture. This is one of a pair of portraits
of Greer, photographed by Maud Sulter during the
making of a BBC4 television programme, *Reflecting
Skin*. The inspiration for the work was Marie-
Guilhelmine Benoist's painting *Portrait d'une Negresse*
(1800). Both Greer and Sulter have highlighted the
role and identity of black subjects in historic and
contemporary art history.

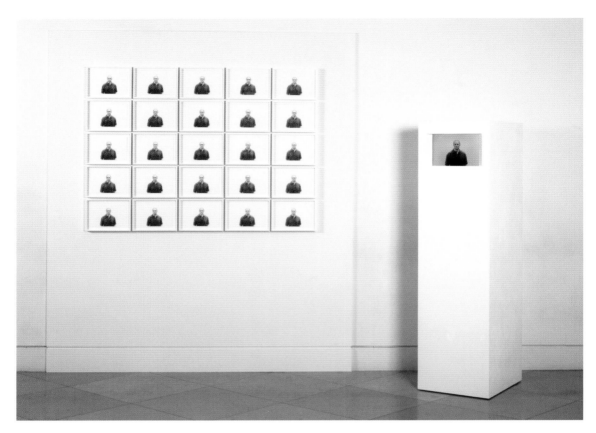

Sustained Endeavour
Dryden Goodwin (b.1971)
High-definition video on continuous loop (above)
featuring 25 pencil-on-paper drawings (right), 2006
Commission made possible by J.P. Morgan through
the Fund for New Commissions, 2006
NPG 6766(2)

Oarsman Sir Steve Redgrave (b.1962) is the only
British athlete ever to have won Gold Medals at five
consecutive Olympic Games. Combining still and
moving images, this portrait by Dryden Goodwin
communicates the powerful combination of mental
focus and dynamic movement required to win. The
meticulously executed drawings, based on the same
photograph, are presented alongside an animated
video display in which they appear in rapid succession.
The five-by-five configuration represents Redgrave's
five Olympic wins. The precision of the drawings
is intended to parallel the oarsman's exceptional
concentration and his dedication to training, while the
animation accumulates the artist's draughtsmanship
into a single, intense, moving image, a kinetic portrait
of Britain's greatest Olympic athlete.

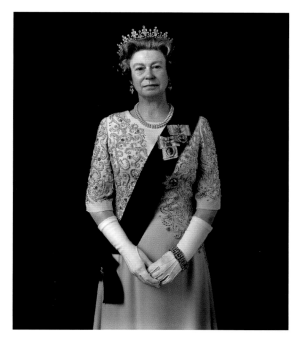

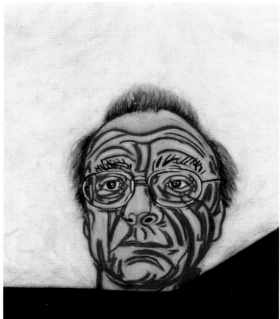

Queen Elizabeth II
Hiroshi Sugimoto (b.1948)
Gelatin silver print laid on aluminium (1 of 5), 1999
1492 × 1194mm
NPG P1002

This strangely disconcerting portrait of Queen Elizabeth II (b.1926), at once lifelike and artificial, is based on a waxwork at Madame Tussaud's. Larger than life, it comes from Hiroshi Sugimoto's *Portraits* series, which includes images of former monarchs such as Henry VIII and his six wives. The artist's work is characterised by meticulous technique and by the creation of groups, or series of portraits, through which he explores notions of time, reality and representation. Playing with both the illusionism of the waxwork and the artificiality of commemorative portraiture, Sugimoto questions the meaning of phrases such as 'from life', 'life-like' and even 'life-size'.

Alfred Brendel
Tony Bevan (b.1951)
Acrylic on canvas, 2005
756 × 670mm
NPG 6720

Sir Alfred Brendel (b.1931) is one of the world's great pianists and the first to record the entire works of Beethoven written for solo piano. From the beginning of the commissioning process it was clear that Brendel was not going to be satisfied with a conventional portrait. However, he was taken with the raw strength and authenticity of Tony Bevan's vision. The sharp diagonal that cuts across the canvas is a reference to Goya's *A Drowning Dog* (1820–23) but is also present in Bevan's earlier *Horizon* series. The finished portrait is the result of an intense period of work over a year, during which Bevan produced preparatory sketches from life followed by drawings and paintings.

Artists' self-portraits

One of the largest groups in the Gallery's Contemporary Collection is that of the self-portrait, reflecting a fascination for the viewer – and maker – with how artists choose to depict themselves. The self-portrait can never be an objective image. By definition it contains something of the artist's psychology and emotional register, at a particular time in their career.

David Hockney's self-portrait shows the artist in the process of painting his subject, friend and former studio manager Charlie Scheips (p.20). The artist peers out of the image towards us, his face squinting slightly as he strains to achieve the exact marks and vivid colours he is searching for – here is a genuine work in progress. Chris Ofili's painted portrait, completed while he was still a student at the Chelsea School of Art in London,

is a more direct and expressive representation (p.18). Conversely, Julian Opie's digital portrait (opposite) and Sarah Lucas's photographic image (p.21) involve constructive processes to produce self-portraits with a purpose. Lucas challenges traditional depictions of women while Opie explores the nature of personal uniqueness. Both artists offer a humorous under-cutting of what can sometimes be seen as an over-serious genre, whereas Tracey Emin's self-portrait (p.19), which is part performance and part narrative, literally exposes the artist to public view.

These works illustrate the many facets of the self-portrait, in which important and relevant issues such as race, gender and cultural background, as well as identity, are often revealed.

Julian with T-shirt
Julian Opie (b.1958)
LCD screen on continuous loop, 2005
1102 × 658mm
Purchased with assistance from Channel 4, 2007
NPG 6830

Julian Opie emerged on the British art scene in the 1980s. Using a distinctive flat graphic style that draws on caricature illustration and paintings from earlier centuries, Opie shows how, by the most minimal means, an individual presence can be brought into a picture. Opie's self-portrait may depict a specific person – himself – but it also explores such issues as the essence of portraiture, the intrinsic elements that convey a person's uniqueness and how a mix of colour and line can convey personality. This computer-animated self-portrait forms part of a series of similar portraits of friends made by the artist.

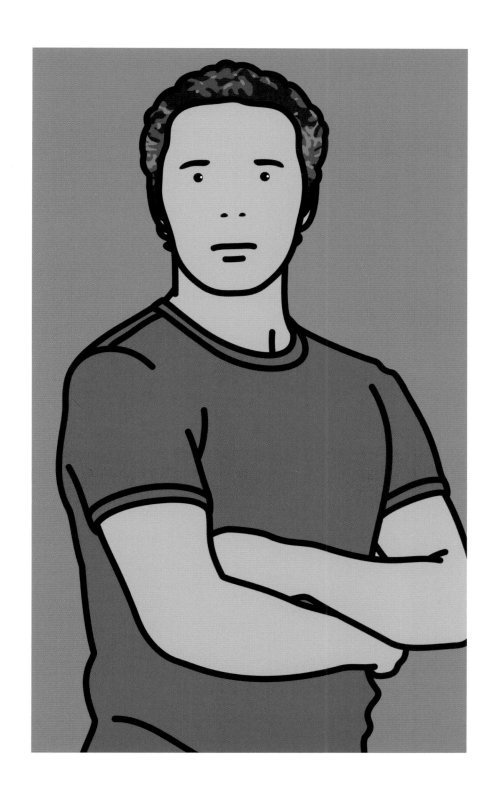

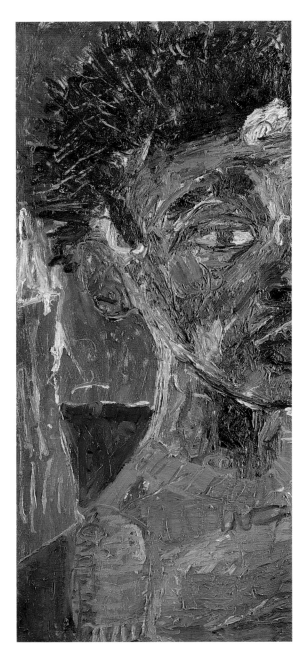

Self-portrait
Chris Ofili (b.1968)
Oil on canvas, 1991
1019 × 442mm
Purchased with assistance from Laura and
Barry Townsley and Janet de Botton, 2008
NPG 6835

Chris Ofili's work often makes reference to his Nigerian
heritage, with images that take racial and sexual
stereotypes as their subject matter. This early painting
is one of a number of self-portraits painted by Ofili
from 1988. It was executed while he was at Chelsea
School of Art (1989–91) and is among the most
compelling of these works, at once more painterly,
directly observed and literal than its counterparts.
It prefigures his later collage-based style when self-
portraiture ceased to be a subject.

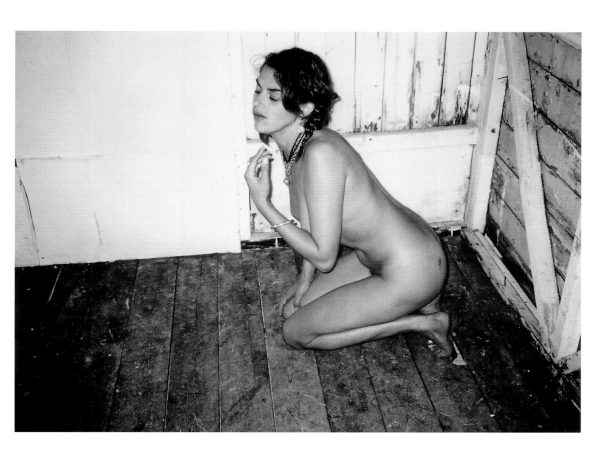

The Last Thing I said to you is don't leave me here
Tracey Emin (b.1963)
Epson print, 2000
813 × 1092mm
NPG P879

Tracey Emin is one of the leading members of the so-
called Young British Artists (YBAs), a loose grouping
of artists including Damien Hirst, Sarah Lucas and later
Chris Ofili that achieved international attention in the
1990s. Emin frequently uses herself as subject matter
for her art. In 2000 she produced four large-scale photo-
based self-portraits, of which this is one. It shows her
posed in the Whitstable beach hut that she purchased
with Lucas in 1992. The hut hints at her Margate
origins; the enclosed space reinforces the claustrophobic
atmosphere that surrounds this very public artist. Emin's
nudity, both provocative and vulnerable, establishes the
ambiguity suggested by the title.

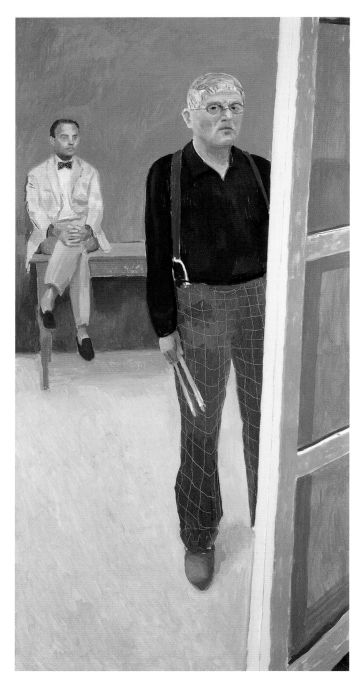

Self-portrait with Charlie
David Hockney (b.1937)
Oil on canvas, 2005
1829 × 914mm
Purchased with assistance from the proceeds
of the 150th Anniversary Gala, 2007
NPG 6819

David Hockney has increasingly turned to the subject
of self-portraiture. This work is one of a series of
large-scale single and double figure paintings made
by the artist in his Hollywood Hills studio in 2005.
All the portraits were completed in just a few sittings.
Using oil paints, he worked directly on to the canvas,
without photographic reference or preparatory drawing.
In this self-portrait Hockney explores his fascination
with mirrors and the theme of the artist and model.
The painting presents a triangular exchange of gazes
between the artist, the model and ultimately the viewer.
The model observing the painting unfold is Hockney's
friend and former studio manager, the New York-based
curator, Charlie Scheips.

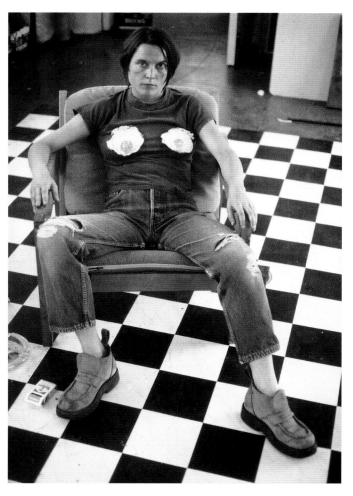

Self-portrait with Fried Eggs
Sarah Lucas (b.1962)
Iris print, 1996
746 × 515mm
Given by Sadie Coles HQ, 2001
NPG P884(5)

Many of Sarah Lucas's works, which use photography, collage and found objects, are visual puns that examine gender in a tabloid-orientated society. Her provocative self-portrait questions traditional depictions of women and challenges the clichéd image of the modern artist at work. This is the fifth in a series of twelve Iris print self-portraits in which the artist appears in her characteristic macho pose and androgynous dress, creating an image of defiant femininity.

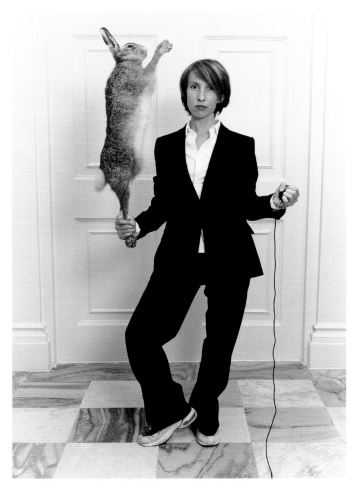

Self-portrait in Single-breasted Suit with Hare
Sam Taylor-Wood (b.1967)
C-type print, 2001
1521 × 1046mm
Purchased with assistance from the artist
and The Art Fund, 2002
NPG P959

Sam Taylor-Wood uses photography, film, video
installation and sound to explore human relationships
and emotions, her acted scenarios drawing on various
sources from Renaissance and Baroque painting to
Hollywood cinema. This challenging and powerful
self-portrait documents a significant moment in Taylor-
Wood's life and career and was made following her
treatment for breast cancer. In her left hand she holds
the contemporary artist's tool, the cable release of
her Mamiya RZ67 camera; in her right hand a stuffed
hare, a traditional symbol used in seventeenth-century
Dutch painting to represent lust and passion and also
an ironic reference to the loss of hair associated with
chemotherapy treatment.

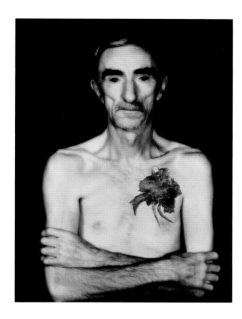

Parasite and Host
Ian Breakwell (1943–2005)
Digitally manipulated photographic print, 2005
1160 × 950mm
NPG P1291

This haunting self-portrait was made by the artist when he was dying of cancer and investigates what Breakwell called 'the surreality of mundane reality', a recurring theme in his work. The crab placed over his lung has a strange dark beauty, a parasite feeding from its host. This intense and painful self-portrait, in which the artist confronts his own mortality, helps to extend the understanding of portraiture and adds to the images in the Gallery that explore transience and death.

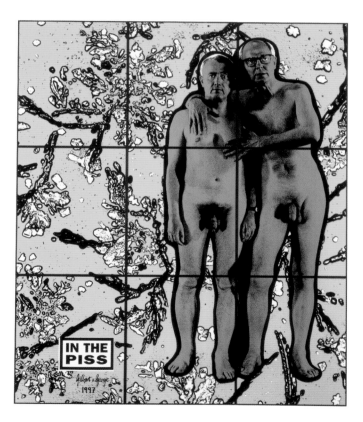

In the Piss
Gilbert and George (b.1943; b.1942)
Photo-piece of 9 panels, 1997
2260 × 1900mm
NPG 6489

Gilbert and George use themselves and their surroundings in their work, the aim of which is to 'take the language of art near to total taboo'. This uncompromising full-length double portrait shows them naked but for Gilbert's watch and George's glasses. They stand before an abstract backdrop derived from a microscopic sample of their own urine; they are literally 'In the Piss', as the title of the work implies. This work of 1997 is part of a series, the *New Testamental Pictures*, all of which combine images of bodily excretions with naked portraits of this artistic partnership.

Commissioning portraits

The National Portrait Gallery commissions five or six portraits a year of people who are making an important contribution to British history and culture. Over the past twenty-five years, it has commissioned some 150 portraits, which now form the backbone of the Contemporary Collection.

Commissions have been an extremely important part of the Gallery's work since 1930, when the Contemporary Portraits Fund was set up to acquire portraits, primarily drawings, of distinguished contemporaries following their deaths. In 1969, under director Sir Roy Strong, portraits of the living were admitted to the Collection, following a relaxation of the previous rule by which sitters could only be considered ten years after their death. In 1980 the annual Portrait Award for painters under forty was introduced, with a commission offered to the winner at the judges' discretion. The following year saw the first commissioned sculpture, Franta Belsky's bronze head of Queen Elizabeth II, and in 1987 the first commissioned photograph, David Buckland's cibachrome of athlete Daley Thompson. The Gallery adopted a more proactive approach to photographic acquisitions in 1998 by initiating a series of profession-based commissions, beginning with Barry Marsden's photographs of thirty chefs, restaurateurs and cookery writers.

Collaborative associations have become increasingly important in enabling new departures. In 2001 the involvement of the Wellcome Foundation resulted in Marc Quinn's DNA portrait of Sir John Sulston (p.13). The portrait of pianist and composer Thomas Adès by Phil Hale (p.27) and the three Royal Court directors by Justin Mortimer (p.38) are part of a series funded by the Jerwood Charity to celebrate younger people prominent in the arts, while the Fund for New Commissions supported the portraits of David Beckham (p.7) and Dame Judi Dench (p.10).

Choosing the subject

Unlike most galleries, the focus of the National Portrait Gallery is on the choice of sitter, rather than the artist. Trustees and curators contribute to a list of possible subjects across all disciplines, while also recognising gaps in the Collection. Decisions on subjects for commissions are then made annually by the Gallery Trustees.

Working with the sitter

The next step is to meet the prospective sitter in order to discuss the choice of artist, perhaps stimulated by an exploration of portraits on display in the Gallery. Some sitters have strong feelings about how they wish to be represented; others are more open to ideas and suggestions. Each commission has a unique story attached to it, and carries an element of unpredictability. A.S. Byatt, for example, favoured a more abstract approach for her portrait (p.4) and was

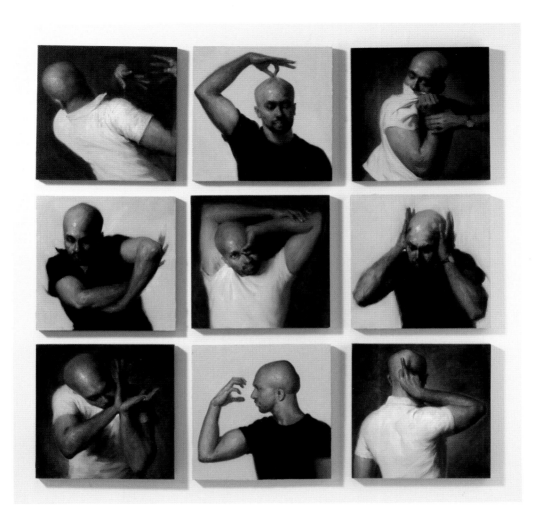

Akram Khan
Darvish Fakhr (b.1969)
9 panels, oil on canvas, 2008
500 × 500mm each
Commissioned with help from the Jerwood
Charitable Foundation through the
Jerwood Portrait Commission, 2008
NPG 6847

Akram Khan (b.1974) was introduced to Bengali folk
dancing as a child and as a teenager he performed
in Sir Peter Brook's production of *The Mahabharata*.
He also studied contemporary dance, and its fusion
with classical Asian dance forms is pivotal to his
choreographic style. Just as Khan has embraced
collaborations with artists throughout his career, so
this multi-panelled portrait by Darvish Fakhr, winner
of the BP Travel Award in 2004, unites performance
and the visual arts. The portrait is based on sketches
and video footage of Khan performing the nine *rasas*,
or emotions, that underpin Indian classical dance and
which provided the inspiration for the work.

keen that Patrick Heron paint it. 'What I wanted was the presence of the idea of me, not of a record of the whole of my face that I don't much like.'

Working with the artist

Careful consideration goes into finding an appropriate artist for a particular sitter and the most successful portraits have been the result of a fruitful collaboration between the two. The Gallery has consistently been willing to take risks, either by encouraging young artists or by approaching established artists who do not usually undertake portrait commissions. Some may not want to be labelled as portrait artists; others simply do not work to commission unless the project is one they find especially fascinating – as was the case with Paula Rego and Germaine Greer (p.5), and with David Hockney and the Christies (p.29).

Creating the portrait

Once artist and sitter are decided on, a meeting is arranged. Younger artists are often very much in awe of a prominent figure as sitter. Harold Pinter described sitting to Portrait Award winner Justin Mortimer, then still in his twenties: 'He kept asking me to be still. "I am still," I said. "No," he said, "you must be absolutely still. My whole career is at stake."' If all goes well, a series of sittings is scheduled, and the scale and nature of the commission agreed. The process can take months or even years to complete, but during this time the Gallery will usually do no more than act as an encouraging observer to the process, only influencing or facilitating where there are difficulties.

Fiona Shaw
Victoria Russell (b.1962)
Oil on canvas, 2002
1828 × 1220mm
Commissioned as part of the First Prize,
BP Portrait Award, 2000
NPG 6609

Fiona Shaw (b.1958) is one of Britain's finest classical actresses. Her stage performances are characteristically controversial and powerful, notably her title roles in *Richard II*, *Electra* and *Medea*. Working from the figure is Victoria Russell's passion. This portrait involved two to three sittings a week for three months at the actress's London home. The artist found Shaw to be such a strong presence that she needed to work alone in her studio for several weeks to resolve the painting. The finished work, in which the subject is set against folds of drapery as a theatrical reference, is striking for its sheer scale and presence.

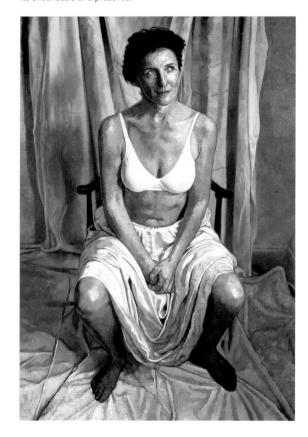

Thomas Adès
Philip Hale (b.1963)
Oil on canvas, 2002
2138 × 1073mm
Commissioned with help from the Jerwood
Charitable Foundation through the
Jerwood Portrait Commission, 2002
NPG 6619

Thomas Adès (b.1971) is recognised as one of today's
foremost classical composers. The portrait by Philip
Hale combines a nod to tradition with a contemporary
influence: the swagger portraits of Sargent with the
soul-searching of Schiele. Over seven months, Hale
made numerous photographs, drawings and oil
sketches to establish a suitable context and pose. Adès
did not want to be portrayed in the predictable setting
of a concert hall and favoured a dark, anonymous
corner of his London apartment. His twisted pose
echoes the shape of a musical note; his right hand is
contorted as he exercises his fingers after a fall. Hale's
high viewpoint adds drama to the composition and
accentuates a sense of discomfort, softened by the
play of textures in the folds of the linen suit and the
reflective glass of the table.

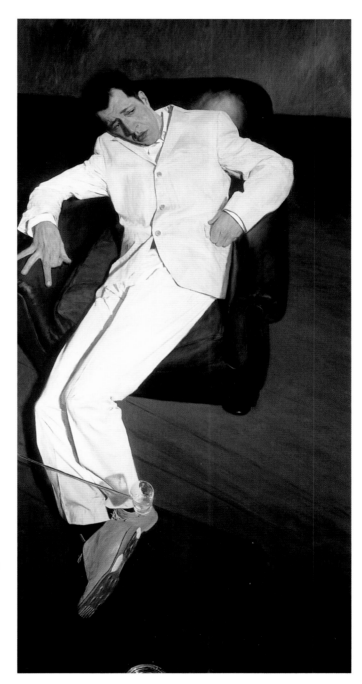

Mo Mowlam
John Keane (b.1954)
Oil on canvas, 2001
1528 × 1224mm
NPG 6468

Gulf War artist John Keane came to the Gallery with a proposal to paint a group portrait commemorating the Northern Ireland Peace Negotiations. When talks broke down, some of the group were no longer willing to sit and so the commission became a portrait of Dr Mo Mowlam (1949–2005), Secretary of State for Northern Ireland from 1997 to 1999 and one of Tony Blair's most popular ministers with a human attitude to politics. The work represents an unusual, contemporary approach. Mowlam didn't wish to sit for her portrait – she found it impossible to sit still – and Keane didn't want to paint from life, so he worked from digital stills, which add a pixellated quality to the image.

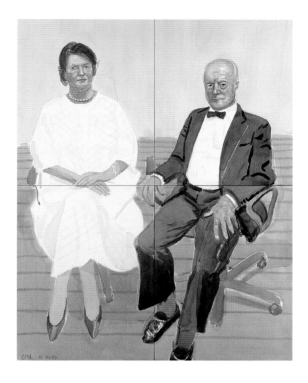

Sir George and Lady Christie
David Hockney (b.1937)
Watercolour, 2002
1220 × 915mm
Donated by the artist
NPG 6624

David Hockney's friendship with Sir George (b.1934) and Lady Christie dates to 1972, when he undertook the stage designs for John Cox's Glyndebourne productions of *The Rake's Progress* and *Die Zauberflöte*. In search of a contemporary approach to portraiture, in 2002 he began to explore the medium of watercolour and found its immediacy and fluidity well suited to portrait work. The Christies' portrait was produced entirely from life without the need for photographic reference. This commission became the catalyst for a new series of double portraits of Hockney's London friends.

Sir Iqbal Sacranie
Don McCullin (b.1935)
Silver gelatin print, 2006
(1 of 10 from the Faith and Church series)
490 × 395mm
NPG P1287

The Faith and Church series represents a journey
through the cultural diversity of contemporary Britain.
The portrait of Sir Iqbal Sacranie (b.1952), Secretary
General of the Muslim Council of Great Britain, is
one of ten representing the major faiths of today.
The Gallery's decision to commission Don McCullin,
documenter of human tragedy and conflict, to make
the portraits may seem perverse. The strength of his
work, however, lies not simply in bearing witness but
in his exploration of light and composition, and in his
innate humanity. Each portrait is set in an environment
that reflects the sitter's spiritual life. The settings
are rich with information, the lighting emotive, the
compositions quiet, while the sitters are presented
as dignified and eminent.

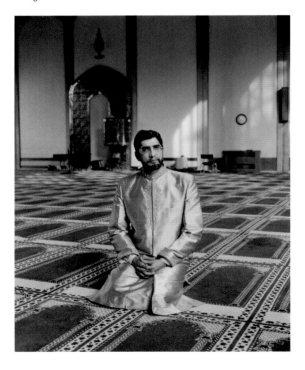

Sir David Hare
Paula Rego (b.1935)
Pastel on paper, laid on board, 2005
1300 × 1230mm
Commission made possible by J.P. Morgan through the
Fund for New Commissions, Sir Christopher Ondaatje
and The Art Fund, 2005
NPG 6746

The artist described this portrait of playwright Sir David
Hare (b.1947), produced in ten three-hour sittings
at the artist's London studio, as a painting 'with the
whole of theatre in it' – entirely fitting in view of Hare's
long association with London's National Theatre.
The suggestion that a performance is taking place is
characteristic of Rego's work. Commenting on the
lamb, a prop she made herself, she said: 'The things I
couldn't get into David's face I put into the sheep's face
... it goes well with him and looks after him.' With a
nod to James Ensor, a theatrical mask lies on the floor.

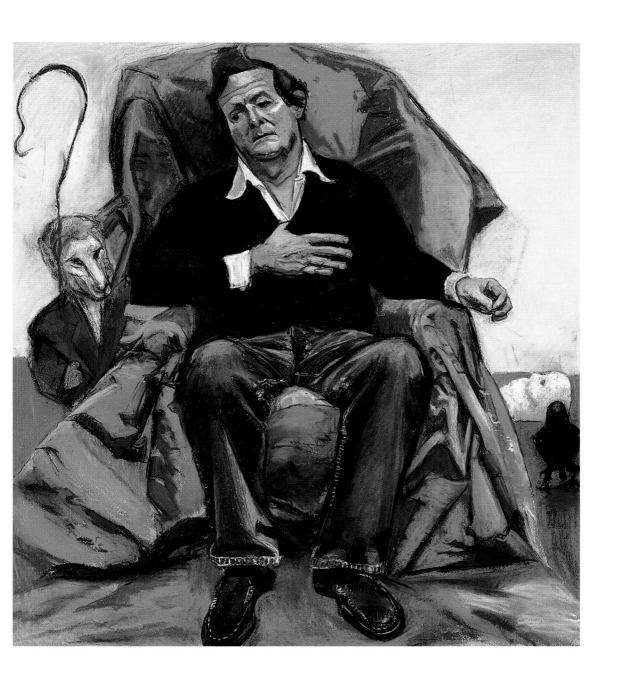

The artist's process

Every portrait has an underlying narrative and this section illustrates the artist's process by telling the stories behind the production of some of the Gallery's recent commissions.

Sketchbooks and photographs, working drawings and plaster casts, all provide insights into the different working practices of the artists who create them. For example, as part of their commissions to make portraits for the Gallery, artists Stuart Pearson Wright, Andrew Tift and Tomas Watson kept diaries recording the process. These detail the progression of the works and reveal common dilemmas and anxieties.

Every portrait in this section involved sittings from life. Some were painted in their subjects' homes, where the surroundings proved inspiring. But the crucial element in the making of these portraits is the relationship between the artist and sitter, which Pearson Wright describes as the 'very particular intimacy of a set of portrait sittings'.

Systematic practice

Andrew Tift has a methodical approach to portrait painting. When commissioned by the Gallery to paint the politicians Neil and Glenys Kinnock, he asked that they complete a questionnaire to gain an understanding of their expectations.

Tift arranged for six sittings with the couple at their homes both in Wales and in Brussels, during which he made sketches and took over 500 reference photographs of the sitters and their various surroundings.

They are depicted here in their home in Wales; objects, such as family photographs and the busts of Nelson Mandela and Aneurin Bevan, were selected for their individual significance to the sitters' lives and careers. The portrait was then painted in the artist's studio using the preparatory reference photos taken earlier.

Attached to the back of the completed canvas, as part of Tift's customary practice, is the brush used by the artist.

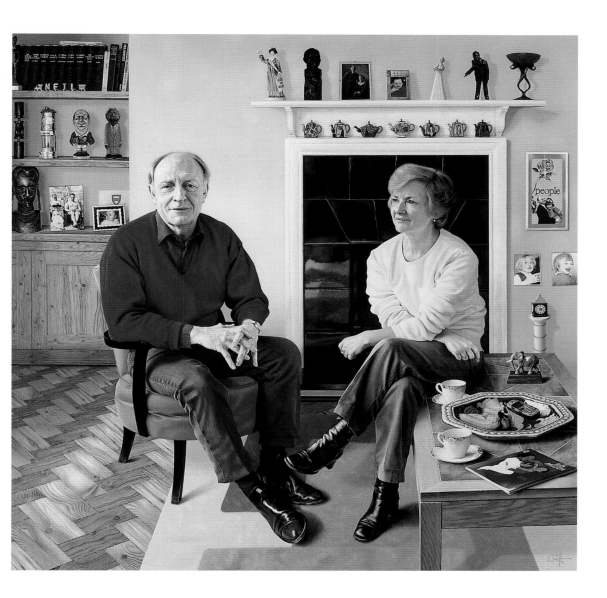

Neil and Glenys Kinnock
Andrew Tift (b.1968)
Acrylic on canvas, 2001
1330 × 1386mm
NPG 6583

This double portrait of politicians Neil and Glenys
Kinnock (b.1942; b.1944), by Andrew Tift, winner of
the BP Travel Award 1994, and overall winner of
the BP Portrait award in 2006, is intended to show their
private rather than their public selves.

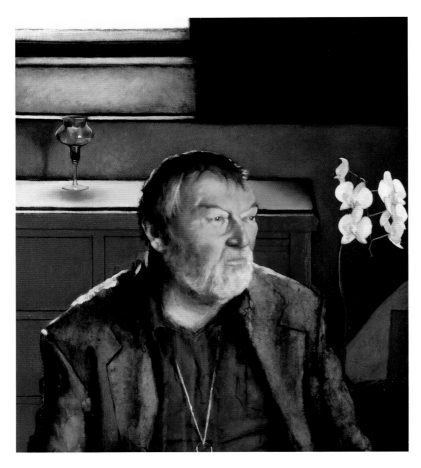

John Fowles
Tomas Watson (b.1971)
Oil on linen, 2001
712 × 614mm
Commissioned as part of the First Prize,
BP Portrait Award, 1998
NPG 6584

Writer and master of layered story-telling
and ambiguous endings, John Fowles
(1926–2005) is pictured looking out
of the window at the Cobb, Lyme Regis,
an important location in his novel
The French Lieutenant's Woman.

Spontaneous intervention
Tomas Watson travelled from his home
in Greece to Lyme Regis in Dorset to paint
the writer John Fowles for the Gallery.
After posing for an initial pencil drawing,
Fowles sat for the artist thirteen times.
Watson also worked on the portrait in the
sitter's absence, from memory, adjusting
the composition and expression. He kept
a diary and photographed the work at
every stage of the portrait's development.
Mid-way through its creation, he
introduced a black glaze, an act he
described as 'solving the painting'.

Reconstructing identity

The sculptor Eduardo Paolozzi worked through several stages before creating his bronze bust of the architect Richard Rogers. He initially made several naturalistic plaster casts showing Rogers with a variety of facial expressions. From these he made a series of drawings on tracing paper that explored different approaches to the head, including the concept of the bust being broken down and realigned. Paolozzi then returned to the plaster casts, which he cut up and reconstructed, producing two further plaster busts with a split facial expression. The Gallery then chose one to have produced in bronze.

Sir Richard Rogers
Eduardo Paolozzi (1924–2005)
Bronze bust, 1988
514mm high
NPG 6021

In this portrait of Sir Richard Rogers (b.1933), architect of the Centre Pompidou in Paris, Eduardo Paolozzi applied the principles of collage to the medium of sculpture to create a work of suitably architectural quality.

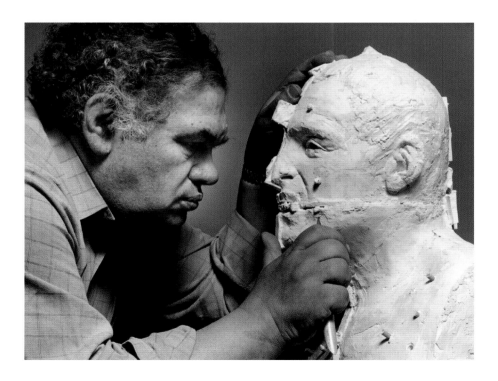

3D vision

When Stuart Pearson Wright first visited
J.K. Rowling in Scotland, he had not
yet conceived the unusual portrait he
finally created for the Gallery, a striking
three-dimensional construction in mixed
media. The artist accompanied Rowling
to the café where she wrote much of the
first of her Harry Potter books, which
have captured children's imaginations
the world over, and made several pencil
sketches. He also took photographs for
reference. Pearson Wright has placed
Rowling in a surreal and disconcertingly
distorted space, in which he mixes 2D and
3D elements, influenced by toy theatres.

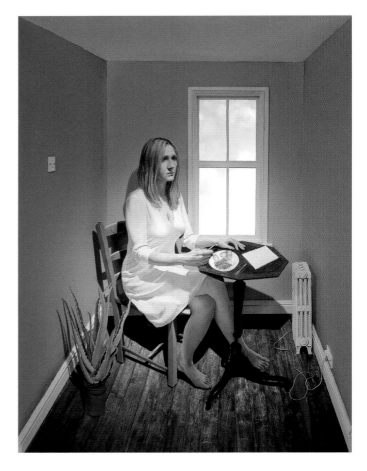

J.K. Rowling
Stuart Pearson Wright (b.1975)
Oil on board construction with
coloured pencil on paper, 2005
972 × 720mm
Commissioned as part of the First Prize,
BP Portrait Award, 2001
NPG 6723

The portrait of J.K. Rowling (b.1965) reflects on her
roles as a writer and a mother (the eggs represent her
three children). Pearson Wright's use of compressed
and distorted space suggests illusion, with echoes
of *Alice in Wonderland* and the parallel world created
in the author's Harry Potter stories.

A graphic framework

When Emma Wesley came to paint
Johnson Beharry, she was already familiar
with his face from newspaper reports
when he was awarded the Victoria Cross
for outstanding acts of bravery in Iraq.
Wesley had three sittings with Beharry
in the front room of his London flat.
They experimented with different uniforms
and poses, and eventually chose full
military dress rather than combats, since
Beharry was no longer on active service.

Taking inspiration from the Gallery's
portrait of the Victorian cavalry officer
Frederick Burnaby, by nineteenth-century
French artist Tissot, Wesley used the
colours and forms of the uniform,
particularly the red stripe, to create
a graphic structure for the portrait.

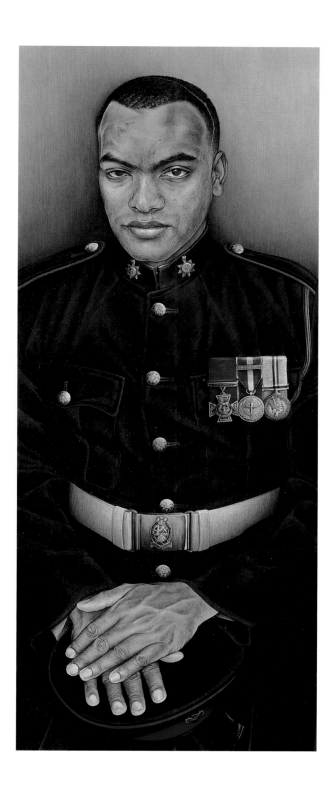

Johnson Beharry
Emma Wesley (b.1979)
Acrylic on panel, 2006
804 × 336mm
NPG 6803

Lance Corporal Beharry (b.1979) is the first person
since 1965 to be awarded the Victoria Cross, Britain's
highest award for gallantry, and its youngest living
recipient. This is a portrait of a soldier, the crossed
hands echoing the form of the medal that he wears,
its vivid pink ribbon used by the artist effectively to
colour the whole portrait.

Computer-aided technique

When considering how to depict three Royal Court Theatre directors – Stephen Daldry, Katie Mitchell and Ian Rickson – in this portrait, Justin Mortimer decided that their disparate personalities and the dynamic between them were the key to resolving the composition. The work is the result of a single, two-hour sitting, which took place in a rehearsal studio at the Theatre in London. The artist observed the sitters interacting with one another and took 100 photographs. He then manipulated these images on a computer – cutting and pasting bodies and limbs – to create a number of different compositions, which he worked up in different media, including drawings, watercolours and oils, drawing on diverse influences from Degas and Sickert to Richter and Tuymans. Mortimer deliberately left the composition unbalanced to create what he describes as 'an annoying psychological dissonance'.

Three Royal Court Theatre Directors
Justin Mortimer (b.1970)
Oil on canvas, 2004
1780 × 2035mm
Commissioned with help from the Jerwood Charitable Foundation through the Jerwood Portrait Commission, 2004
NPG 6668

This group portrait of Stephen Daldry (b.1961), Katie Mitchell (b.1964) and Ian Rickson (b.1963) illustrates the interaction between a work's painted surface and its psychological depth. By engulfing the interlocking figures in a dark imaginary space, Justin Mortimer captures all the tension of a piece of theatre.

The long-term view

When Dean Marsh first met Camila Batmanghelidjh, he was immediately drawn to her distinctive style of dress. He found inspiration for the sitter's elegant pose and the depiction of sumptuous fabric in the portrait of Madame Rivière by the nineteenth-century French artist J.D. Ingres. Marsh prefers to paint from life over a long period, but in this instance was able to secure only a limited number of sittings with Batmanghelidjh. These took place in her office, where Marsh made sketches of her face and hands. By constructing a life-sized model of the sitter in his studio, he could continue to work on the costume and drapery in her absence.

Camila Batmanghelidjh
Dean Marsh (b.1968)
Oil on panel, 2008
763mm diameter
Commissioned as part of the First
Prize, BP Portrait Award, 2005
NPG 6845

In this portrait of Camila Batmanghelidjh (b.1963), psychotherapist and founder of the charity Kids Company, the artist has alluded to her career by including a small broken horse, one of a number of models made by children that decorate the sitter's workplace.

In their own words: interviews with artists

The commissioned portrait is the outcome of a complex dialogue between sitter, artist and the Gallery that brings them together and on whose walls the finished work will finally appear. The interviews that follow explore the relevance of portraiture to four very different artists.

MARC QUINN

National Portrait Gallery:
Why has the image of the body been so important throughout your work?

Marc Quinn:
All my work is about embodiment and disembodiment. It's about what it means to be a person, living in a body, and how that body relates to other bodies and to the world. To make a sculpture that is also a real object in the world is, to me, an interesting way to address those issues, to make you aware of that basic structure of life.

National Portrait Gallery:
What has been the significance of the self-image in your work?

Marc Quinn:
When I made the first *Self* in 1991, I wanted to make a sculpture that was as close to a living thing as it could be, that would be made literally from the same substance as myself. And yet, paradoxically, the closer the work became to a human being – made from human tissue, with the form of a human, maintained by a mechanical system of freezing – the more it seemed to stress the difference between a living being and a manmade object like an art work.

National Portrait Gallery:
How did well-known subjects like Alison Lapper and Kate Moss come to be part of your work?

Marc Quinn:
After making sculptures based on myself, I moved on to other people. It is a way of representing the relationship between myself and other people in the world. In the case of Alison, the sculpture (*Alison Lapper Pregnant*, 2005) is one of embodiment. It is a question of inside and outside. Inside she is a whole person; only on the outside is she perceived as not being a whole body. With Kate Moss, the sculpture (*Sphinx*, 2006) is a disembodiment; it is a sculpture of an image of her – a cultural hallucination almost. Kate Moss in real life and as an image are quite different, and this is definitely a sculpture of the latter.

National Portrait Gallery:
Do you see portraiture playing a large part in your work in the future?

Marc Quinn:
Portraiture is likely to remain central to my work. It is about people, how they see themselves in the world, and how they relate to each other.

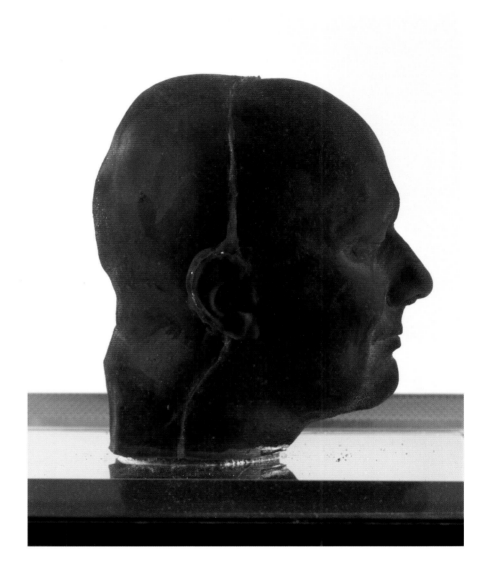

Self
Marc Quinn (b.1964)
Blood, liquid silicon, stainless steel, glass,
Perspex and refrigeration equipment, 2006
2050 × 650 × 650mm
Purchased with help from The Art Fund, the Henry
Moore Foundation, Terry and Jean de Gunzburg and
ProjectB Contemporary Art, 2009
NPG 6863

Both challenging and provoking, Marc Quinn's work
has raised many questions about the representation
of the human figure in contemporary culture (see p.13).
Self is the latest in a series of life casts made of his own
head and created from his own blood, which document
the process of transformation and deterioration.
Of human proportions, it sits on a polished base that
reflects the viewer, so the work can be regarded as
both a self-portrait and portrait of everyone.

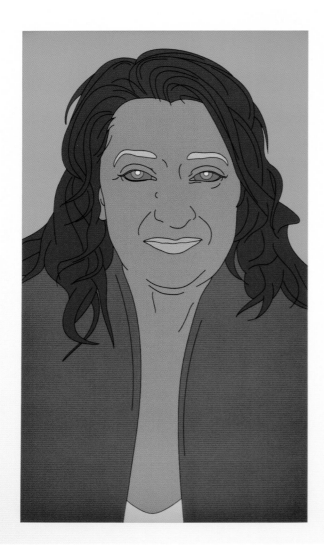

Zaha Hadid
Michael Craig-Martin (b.1941)
Wall-mounted LCD monitor/computer
with integrated software, 2008
Commission made possible by J.P. Morgan
through the Fund for New Commissions, 2008
NPG 6840

Michael Craig-Martin's portrait of Zaha Hadid
consists of a live LCD monitor that hangs on
a wall like a painting and displays a line drawing
of Zaha Hadid wearing an Issey Miyake jacket.
While the linear drawing is fixed, the intense
colours in the portrait and its background slowly
but constantly change. These changes are controlled
by live computer software, encased in the monitor,
which makes random choices. There are so many
variables that no one will ever see precisely the
same image twice.

MICHAEL CRAIG-MARTIN

National Portrait Gallery:
Your first experimental venture into portraiture was your portrait of Zaha Hadid, followed by another of your grandson and a series of self-portraits. This has launched you into a quite different area of work, which you call your 'computer work'. Did you find it difficult to make the transition from physical materials?

Michael Craig-Martin:
I drew Zaha exactly the way in which I would draw anything else ... and that means taking lots of photographs, finding one that I think is correct, and then ... making a drawing from the photograph. I have been using the computer as a work aid since the mid-1990s. It is extraordinarily well suited to how I think and work and has transformed my practice. This then led to ideas for works made exclusively for computers, such as the portraits.

National Portrait Gallery:
By drawing Zaha Hadid's head deliberately larger than life-size, you focus our attention on her strong features and direct gaze, conveying a powerful sense of authority and charisma. You also use colour to delineate one feature from another, as you do when distinguishing one object from another. And your computer portraits continue your trademark bright palette. But although the image is fixed, the colours of the hair, eyes and lips are constantly changing, as the computer software makes its selection. To what degree do you choose to influence this process?

Michael Craig-Martin:
I choose the palette of colours but I don't choose the combinations. To be honest, the choices the computer makes sometimes absolutely astound me ... I'm very struck by the fact that sometimes Hadid can look terrifying and demonic, and other times she looks as sweet as a kitten, and then there's all the range in between.

National Portrait Gallery:
For an artist whose subjects are generally everyday objects and their relationship with the spaces they inhabit, portraiture has provided a new direction. Did Hadid's work as an architect influence you?

Michael Craig-Martin:
The principle characteristic of her own designs is a kind of fluidity ... it's as if they are captured movement, and as you go through the space, it gives you a strong sense of the dynamic of change. It's that kind of change that's in the computer work. It's an organic experience. It's what we're all like. Every time we see each other we look more or less the same, but things about us have changed, and our moods are shifting all the time ... it seems to me this is a very particular equivalent to what it is to be a living organism.

JASON BROOKS

National Portrait Gallery:
Mortality and the fugitive image are central themes in your portraiture, whether the subject is cancer specialist Sir Paul Nurse, racing driver Jenson Button or tattooist Zoe Wendle. What is the significance of this?

Jason Brooks:
Making paintings that are forensic in their detail helps in the analysis of somebody's very existence and reveals people exactly as they are. That, for me, is where [the portrait] taps into the essence of mortality. We live in a society that, I suspect, deems that we should look, or be, a certain way, but I would rather people were just as they are. The flaws, the marks – they're the things that I fall in love with.

National Portrait Gallery:
Process plays a critical part in the construction of your paintings. Can you expand on this?

Jason Brooks:
I like to get to know my subjects, their day-to-day existence, the things that interest them. While taking this in, my brain captures their physical attributes. I try to replicate this when I take the preparatory large-plate photograph. Then I make the decision about size, whether to use watercolour paper or linen. The painting builds up slowly. I start with the eye plane. It's a very shallow depth of field – the eyes are in focus while the ears and nose are not. There's a moment where you have a sense of slippage, when things are in and out of focus, a metaphor. I use an airbrush and black pigment; then other tools and brushes to erase or add paint and create a different kind of texture.

National Portrait Gallery:
How do you decide on the format?

Jason Brooks:
The large scale is important. The fact that you can see every detail suggests a pornographic and fetishistic way of seeing things. You're scrutinising something, almost like a 'peeping Tom'. A cropped, wide-screen format intensifies the subject's gaze, making it less portrait-like and quite cinematic.

National Portrait Gallery:
From a distance your images are sharply defined, but close-to they appear to be made up of abstract forms. Is this a deliberate part of your work?

Jason Brooks:
I paint from different distances. I'm constantly moving forwards and backwards. Sir Paul, for example, has a different expression at different angles – one is poignant, another is quite devilish. That was something I wanted to capture: an exceptional, multi-faceted person. I think that's the key – from a distance you think it's just a photograph. You walk closer, it breaks down and becomes atomised paint, which adds to the fugitive idea that we're all ephemeral beings.

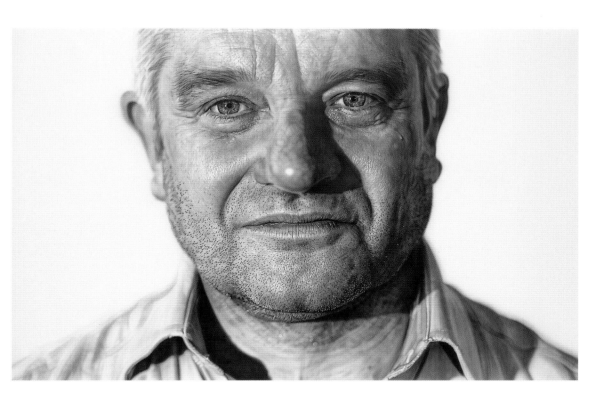

Sir Paul Nurse
Jason Brooks (b.1968)
Acrylic on canvas, 2008
1710 × 2710mm
Commission made possible by J.P. Morgan through
the Fund for New Commissions, 2008
NPG 6837

In 2001 Sir Paul Nurse (b.1949) was awarded the Nobel
Prize for unravelling the mechanism of cell division,
which illuminated medical research and allowed for
more accurate cancer diagnostics. Without overtly
referencing Nurse's role as a microbiologist, artist
Jason Brooks explores through his painting process
the essential make-up of the human form. The portrait,
a large-scale black-and-white image of the scientist's
face, cropped to cinematic effect, shows every pore and
follicle. From a distance it appears as a sharply defined
photograph, but close-to as abstracted airbrushed
forms; an attempt, in the artist's words, to 'get lost
in somebody's structure'.

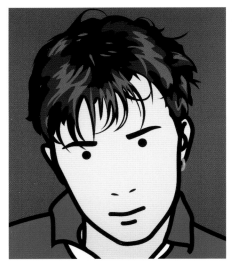
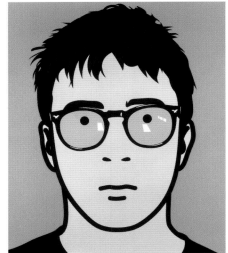
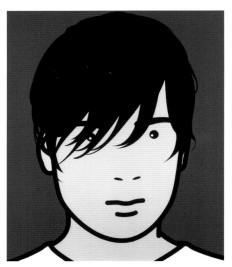

Damon Albarn, Graham Coxon,
Alex James, Dave Rowntree
Julian Opie (b.1958)
C-type colour print on paper laid on panel, 2000
868 × 758mm
Given by The Art Fund, 2001
NPG 6593(1–4)

The band Blur was formed in 1989. Their chart-topping album *Parklife* (1994) announced the band's leading position in the Brit Pop movement. Opie's 'digital drawings' were commissioned for the cover of their 'best of' compilation in 2000. His signature style has the effect of neutralising the star status of his subjects, an effect well suited for the band's 'boys-next-door' image. The commercialisation of the portraits, on hoardings, T-shirts and CDs, has provoked intense Warholesque debate about the relationship between high art and commercial art.

JULIAN OPIE

National Portrait Gallery:
Why has the portrait become such an important part of your work?

Julian Opie:
Among the many terrible reviews for my Hayward Gallery show in 1993 were a few complaints from journalists that there were no paintings of people or trees. Perhaps I saw this as a challenge. Up to then, I had assumed that the viewer played the human role in the installation. I'm not able to draw anything I want. I have to find a language, a network of references that I can manipulate. I remember looking across railway platforms and thinking how, from a distance, people looked like models – all the same yet each a type, each very individual but together making a crowd. I had made sculptures of animals based on children's wooden cut-outs and tried to apply the same logic to drawing people. An image of a person is perhaps greater than any other. Its power radiates out, affecting all around it. Looking at other people, looking at ourselves, fills so much of our minds. Yet it is not polite to stare. Portraiture allows us to really look at strangers.

National Portrait Gallery:
Is there a particular significance to the self-portrait?

Julian Opie:
The self-portraits (there are two, with and without jumper) are titled in the same way as the other works, ie: *Julian with T-shirt* (p.17). So Julian has become another character, separate from myself. I find it difficult to look at myself, it's uncomfortable. I prefer the logic of an artist looking at a third party.

National Portrait Gallery:
Is there a difference for you between commissioned portraits and those that you choose to create?

Julian Opie:
Yes, commissioned sitters pay. I undertook a series of commissioned portraits, thinking that this added another layer of reference to the history of portraiture. 'Why was this person picked?' After some 150 portraits I felt I had dealt with that. Now I keep snapshots of people on file and call them if I need a particular model. I have done projects on whole families, on people in poses from eighteenth-century Japanese prints and a Manga-inspired series.

National Portrait Gallery:
The radical reduction of form to line involves several critical processes. How have these evolved for you?

Julian Opie:
I have always drawn with a line. I think and see in lines. Perhaps being colour blind encourages this. Line lies between the reception of light by the retina and language. Light and retina provide incoming data, while language is the processing of information by our brains, which includes history, experience, reference. Emotion, fear, desire, love and lust lie in-between. There are other ways of drawing but I don't understand them.

Acknowledgements and picture credits

Published in Great Britain by
National Portrait Gallery Publications
National Portrait Gallery
St Martin's Place
London WC2H 0HE

For a complete catalogue of current
publications please write to the
address above, or visit our website at
www.npg.org.uk/publications

10 9 8 7 6 5 4 3 2

ISBN: 978 185514 4040

A catalogue record for this book is
available from the British Library.

Publishing Manager: Celia Joicey
Editors: Rebeka Cohen and Denny Hemming
Design: Thomas Manss & Company
Production Manager: Ruth Müller-Wirth
Printed and bound in Hong Kong

Acknowledgements
Special thanks are due to Rosie Broadley
for the captions on recent acquisitions, and
for her contribution to 'The artist's process'.
For their help in making this book, the
authors are also grateful to Jacob Simon for
guidance on 'Commissioning portraits', to
Liz Rideal for material used in captions for
p.19 and p.23 (below) from her National
Portrait Gallery book Self-portraits (2005), and
to other colleagues and Gallery publications.